Q R S T
U V W X
Y Z A B
C D E F

This book celebrates the memory of Eugene Wesley Jackson
through the thoughtful support of his wife, Marie-Louise Jackson.

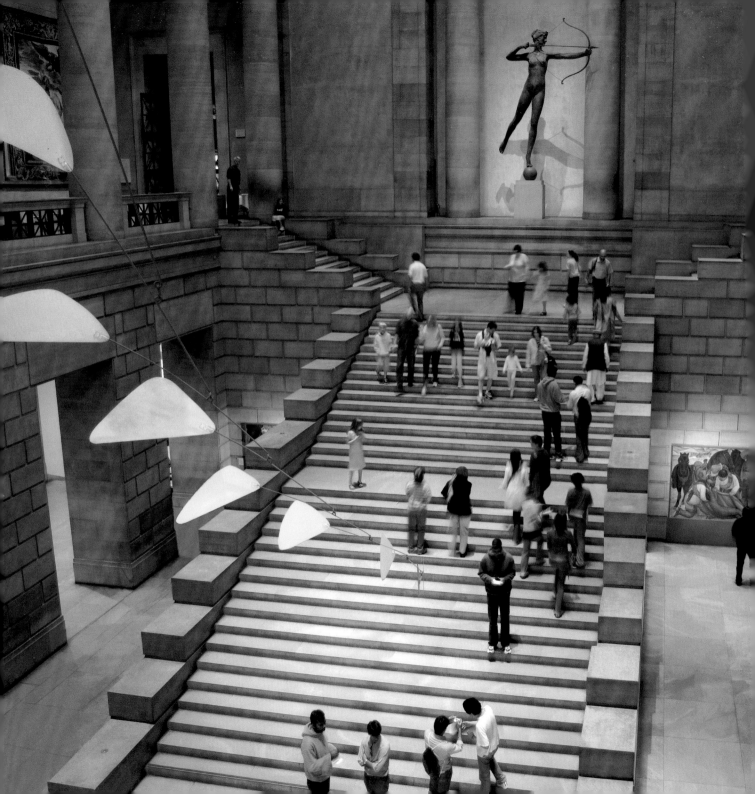

A is for Art Museum

Katy Friedland
Marla K. Shoemaker

Philadelphia Museum of Art
in association with

TEMPLE
UNIVERSITY PRESS

Philadelphia

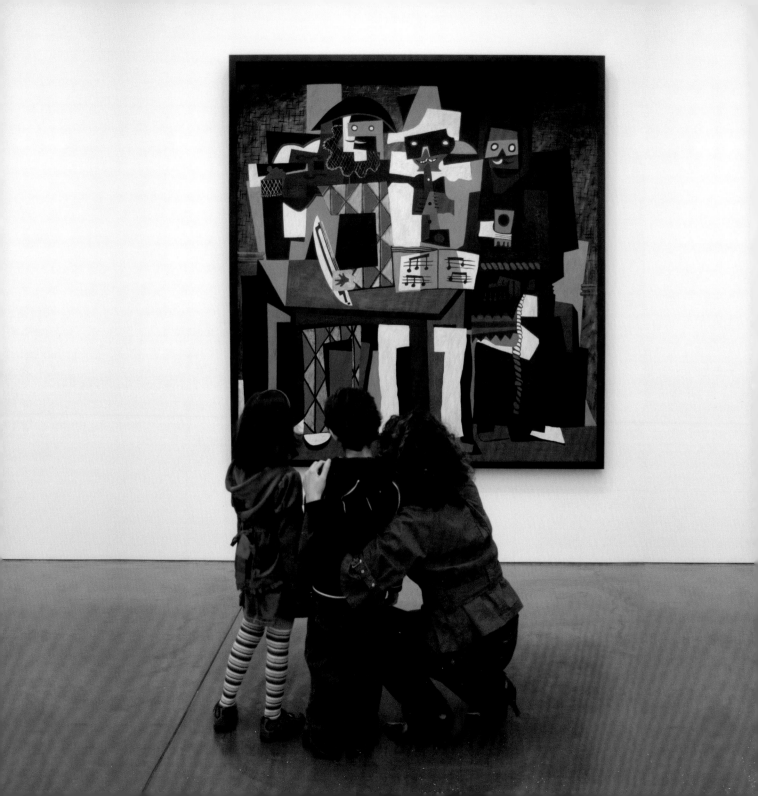

A Welcome from the Director

Art museums are magical places. Filled with ancient and modern wonders from around the world, museums can awaken our imaginations and help us see life and ourselves in new ways. In museum visits we can travel to another time or place; imagine what it might be like to be a ballet dancer or a medieval knight; or enter into a beautiful universe of lines, shapes, and colors.

We have tried to capture some of the excitement in this first ABC book from the Philadelphia Museum of Art. We hope you and your young children spend happy hours poring over the images on these pages, and that the suggested questions spark lively conversations. Last but not least, we extend the warmest of invitations to visit the Philadelphia Museum of Art or any museum that tempts you to experience for yourselves the wonder of works of art.

Like so many Museum projects and exhibitions, this book would not have been possible without a generous donor. We are greatly indebted to Marie-Louise Jackson for supporting this publication in honor of her late husband, Eugene Wesley Jackson. Mr. Jackson left a great legacy of outstanding innovation in the field of medical publications as well as a philanthropic legacy which his children, Susan Lynne Tressider and Geoffrey William Jackson, carry on through the Fourjay Foundation and at HealthLink Medical Center. How wonderful that his grandchildren, Owen, Wade, Cara, and Christian, will enjoy this book, as will so many other children.

Anne d'Harnoncourt
The George D. Widener Director and Chief Executive Officer
Philadelphia Museum of Art, May 2008

A

is for

art museum

Here is a building filled with art.
What will you find inside?

East Entrance of the Philadelphia Museum of Art

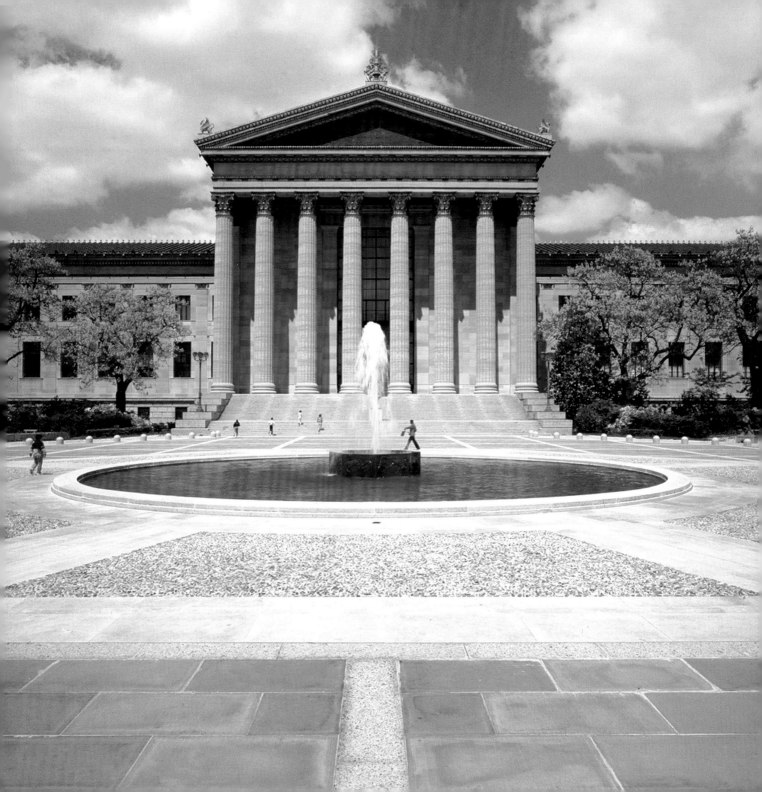

B
is for
bridge

Can you see the trees and bushes?
Water and water lilies?
Where will you play in this garden?

Claude Monet (French, 1840–1926), *The Japanese Footbridge and the Water Lily Pool, Giverny,* 1899

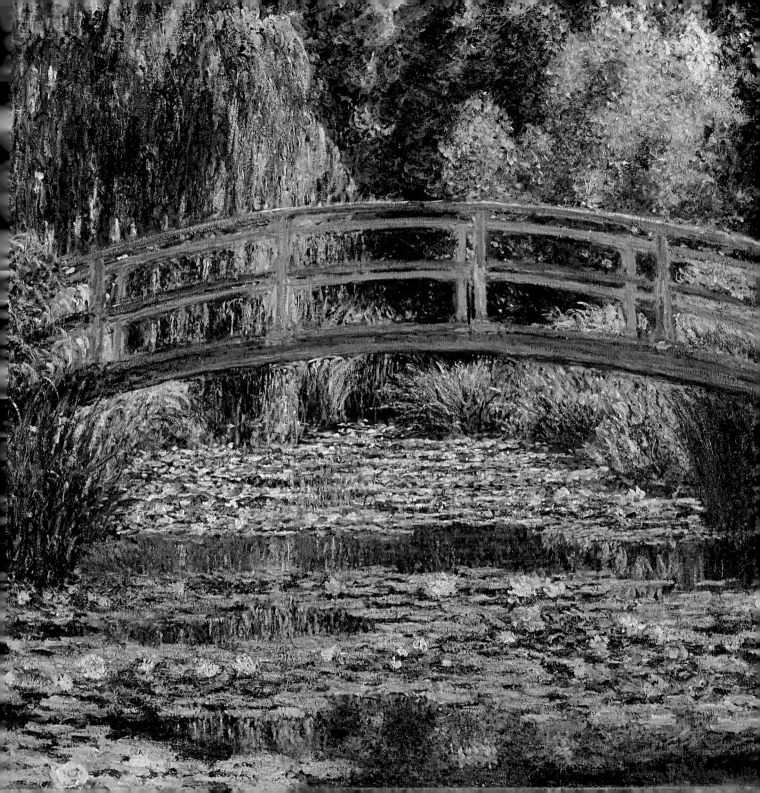

is for

cage

A little dog once slept in this cage.
Can you see where he climbed in and out?

Dog Cage (Goulong). Chinese, Qing Dynasty, Qianlong Period, c. 1736–95

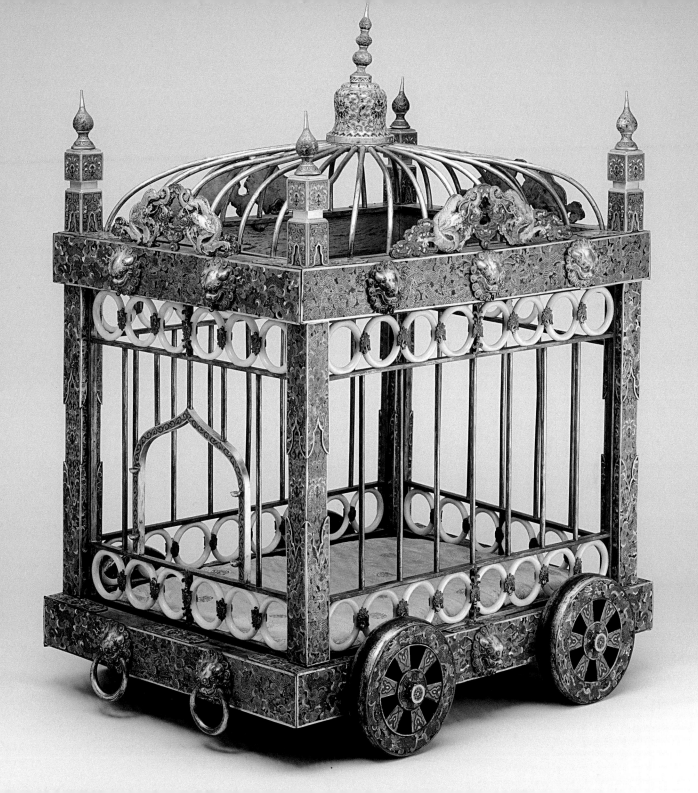

D

is for

dancer

Can you pose like this dancer? How will you hold your head?
Where will you put your feet?

Edgar Degas (French, 1834–1917), *Little Dancer, Aged Fourteen.* Executed in wax 1878–81; cast in bronze after 1922

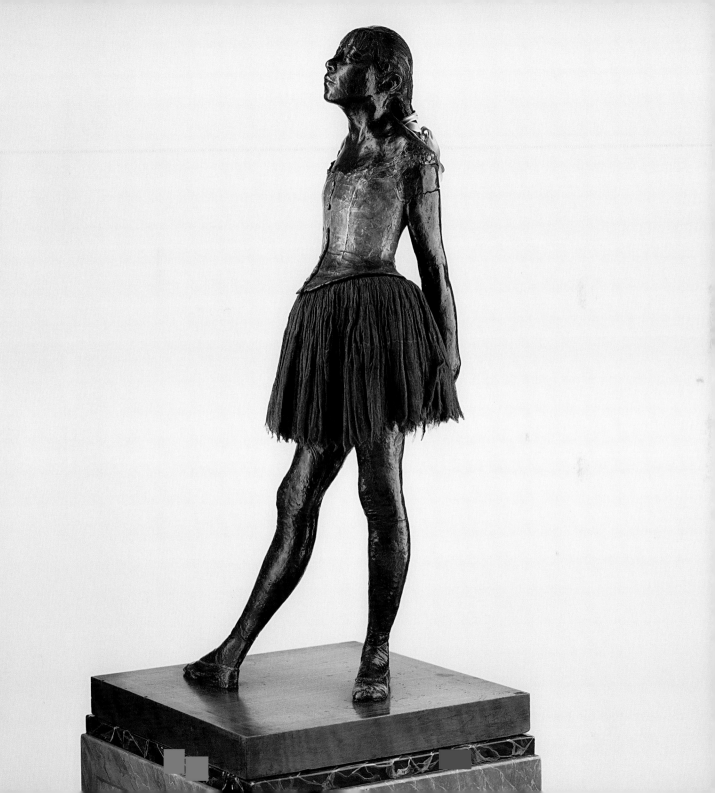

E

is for

eyes

These eyes are painted on jewelry.
Which eye would you wear?
Can you find a painting of two eyes?

Eye Miniatures. English, c. 1780–1800

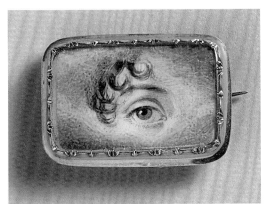
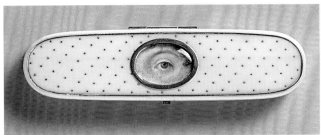
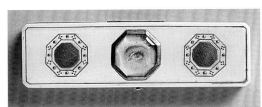
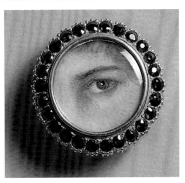
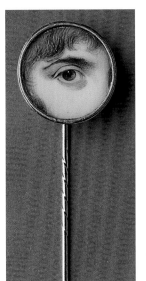
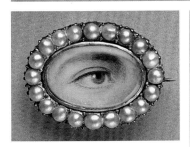
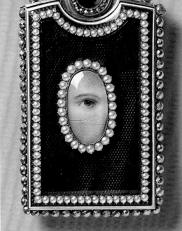
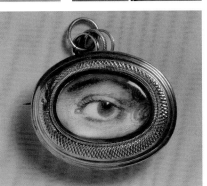
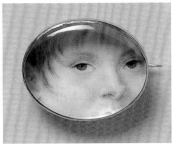

F

is for
fish

Fish come in many colors.
What colors do you see?

Paul Klee (Swiss, 1879–1940), *Fish Magic*, 1925

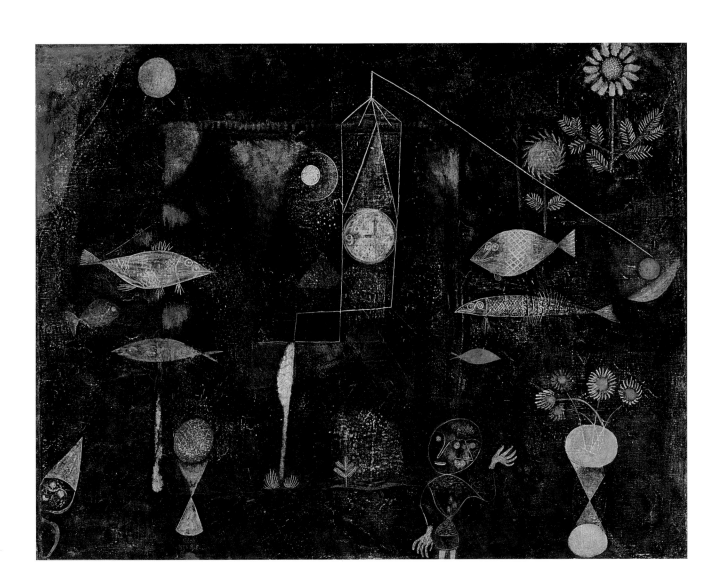

G

is for

garden

Find three birds playing in this garden.
What sounds do birds make?

Fragment of a Tapestry Showing a Courtly Couple. Flemish, c. 1500–1530

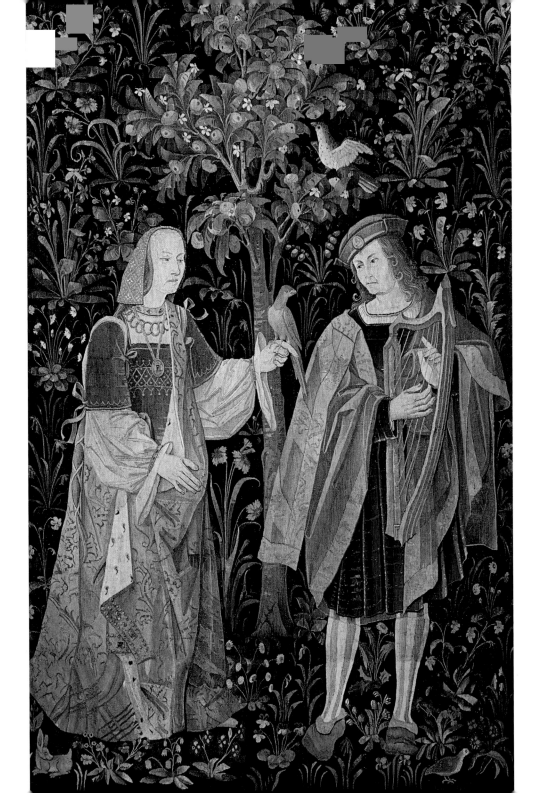

H

is for

helmet

Helmets protect your head. A knight wore this long ago. Who wears helmets today?

Burgonet. German, made for the guard of Duke Christian I, prince elector of Saxony, 1586–91

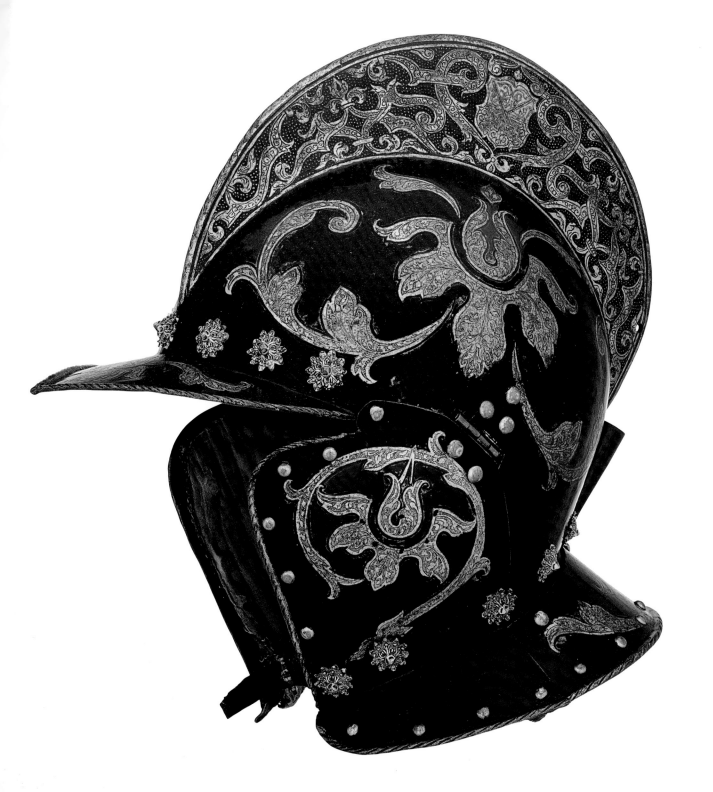

is for

ice

Roar! A polar bear is sitting on the cold, white ice.
What else is white in the painting?

Charles Sidney Raleigh (American, born England; 1830–1925), *Chilly Observation*, 1889

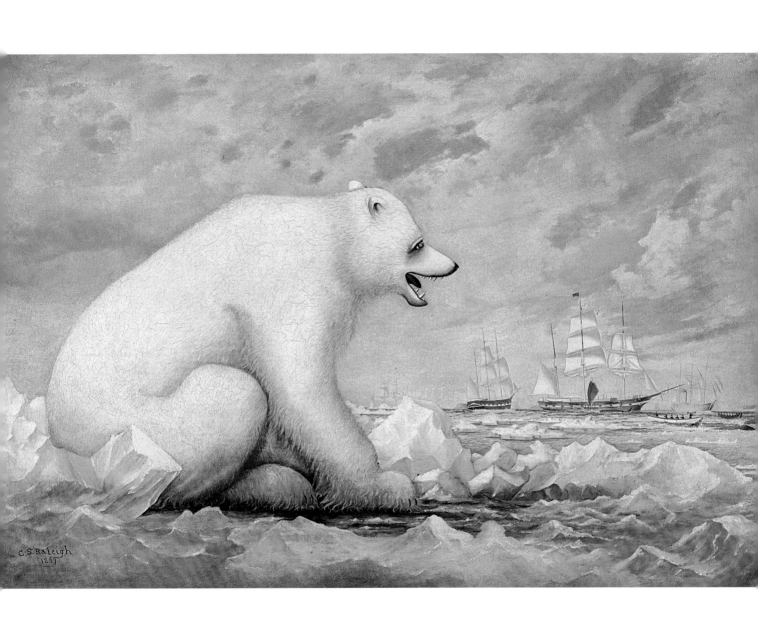

J
is for
jump

The boy is upside down! How did he get that way?
Do you like to jump?

Zoe Strauss (American, born 1970), *South Philly (Mattress Flip Front)*, photographed 2001, printed 2003

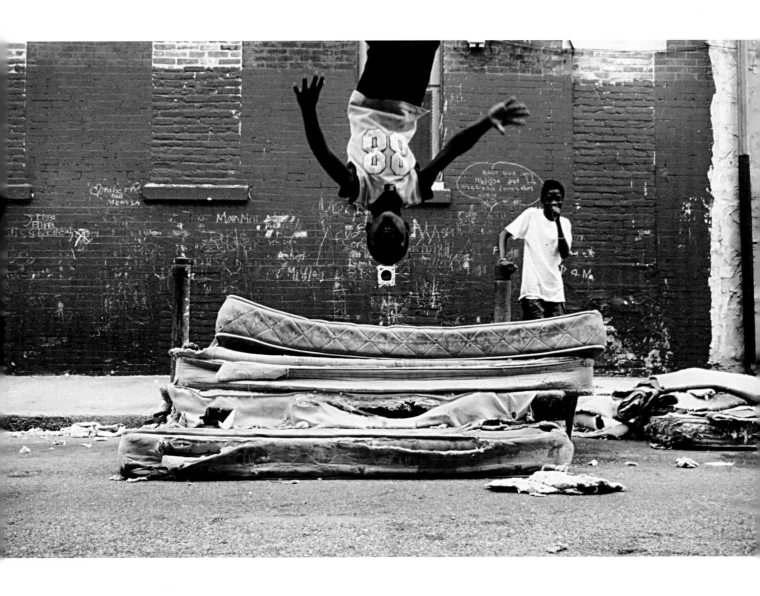

K

is for
kiss

Two people are kissing. Can you see
their eyes, arms, hair, and lips?

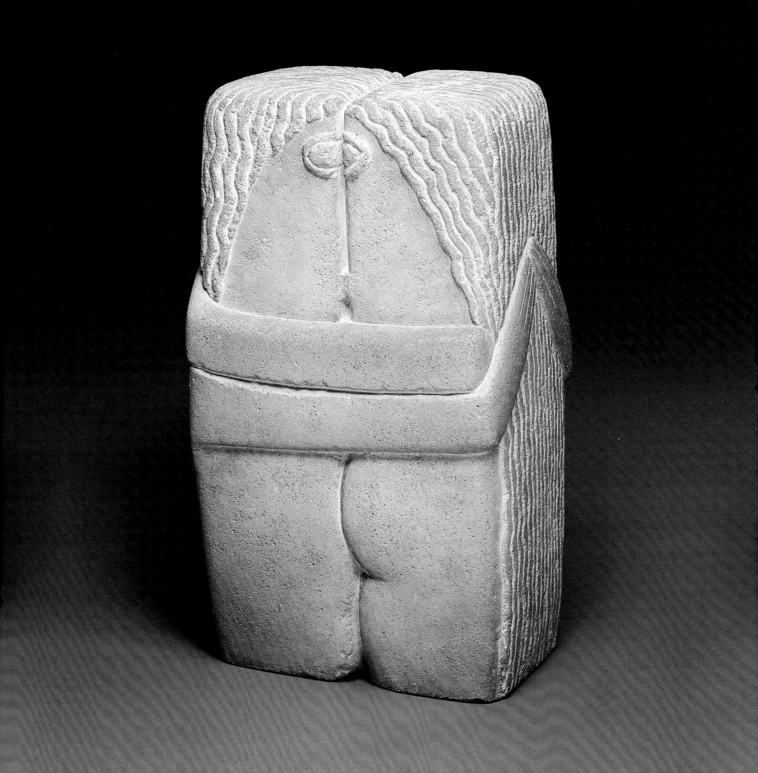

is for
library

Shhh . . . people are reading.
The library shelves are filled with books.
Do you have a favorite book?

Jacob Lawrence (American, 1917–2000), *The Libraries Are Appreciated*, 1943

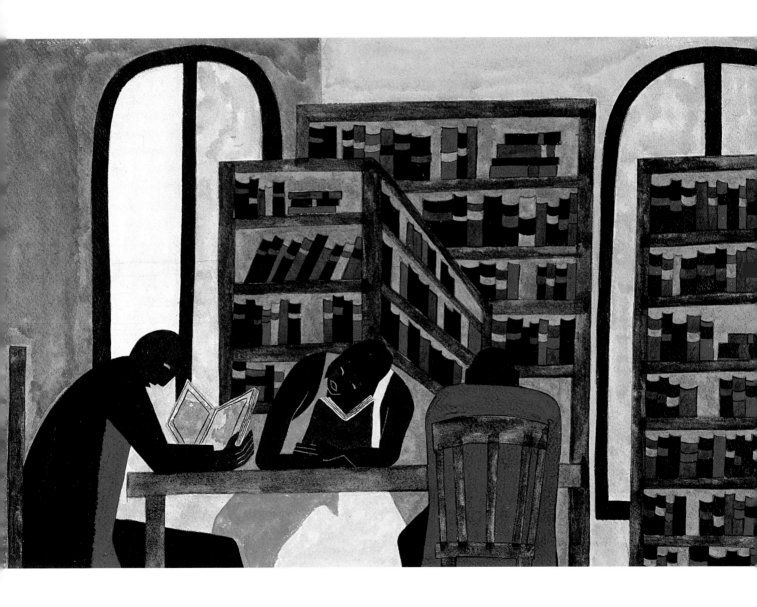

M

is for

music

Three men dressed in costumes play music.
Can you see the circles and lines of their musical notes?
What other shapes do you see?

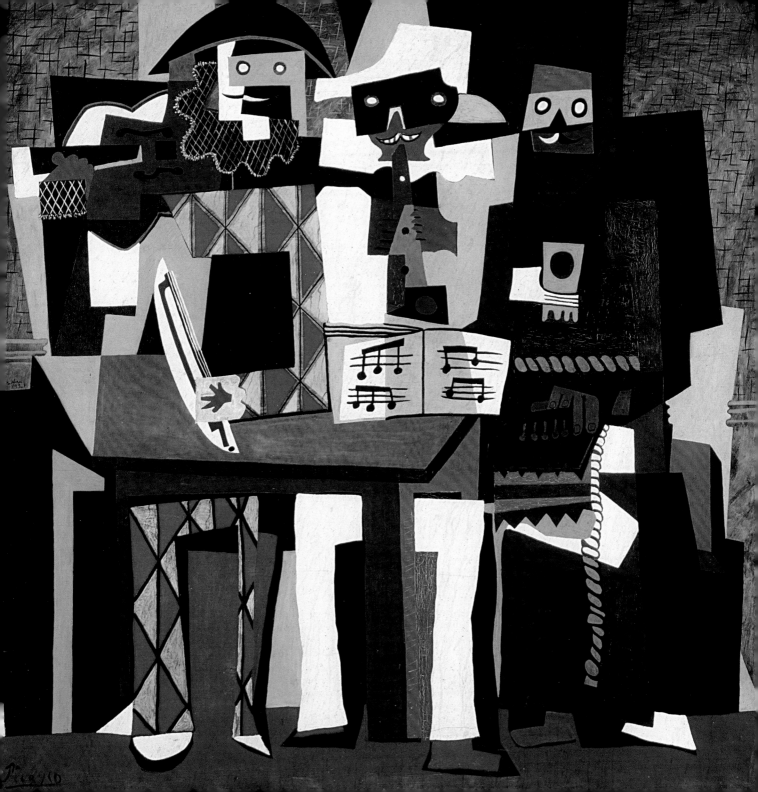

N

is for

neck

Here is a lady with a very long neck.
Can you stretch your neck like this?

Amedeo Modigliani (Italian, 1884–1920), *Portrait of a Polish Woman*, 1919

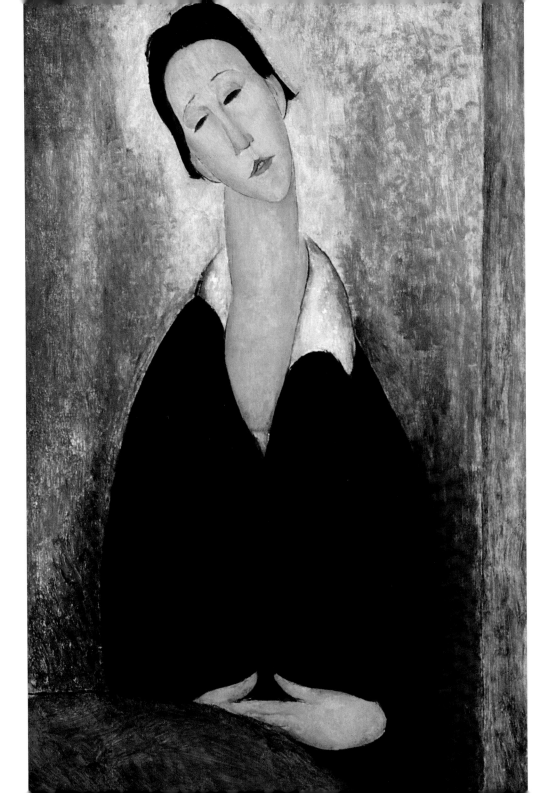

is for

ostrich

This bird once went round and round on a carousel.
Imagine you are riding it. Where will you sit?
What will you hold on to? What will you say to this ostrich?

Ostrich Carousel Figure, Dentzel Carousel Company (Philadelphia, 1867–1928), c. 1903–9

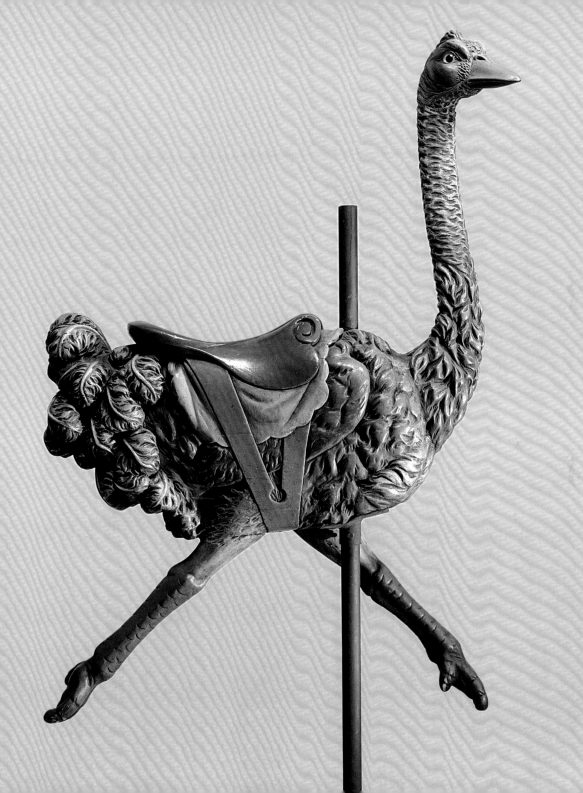

P

is for

pond

What animals have come to
drink from this pond?

The Lover Rides His Horse Far into the Pond to Let Him Drink. India, Madhya Pradesh, Bundelkhand, c. 1800–1825

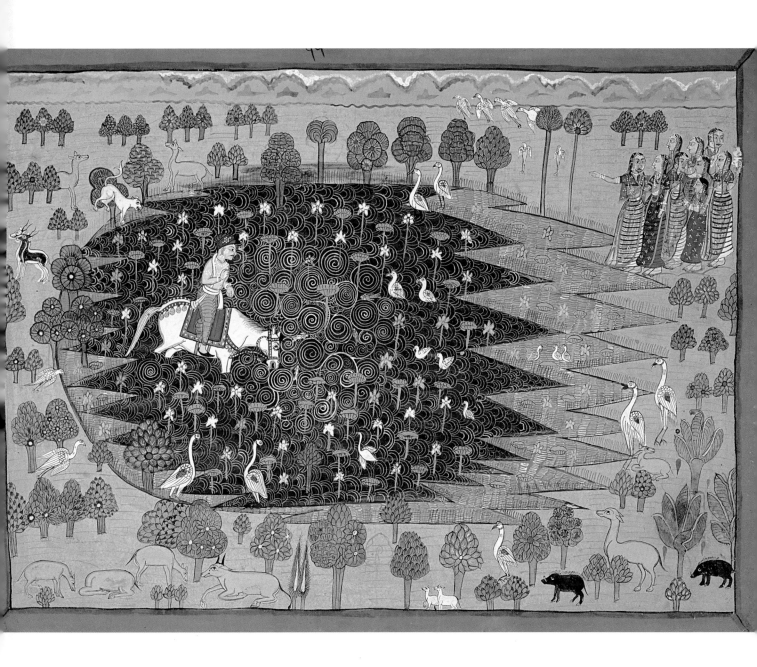

Q

is for
quilt

This quilt is covered with brightly colored hands.
How many colors can you name?

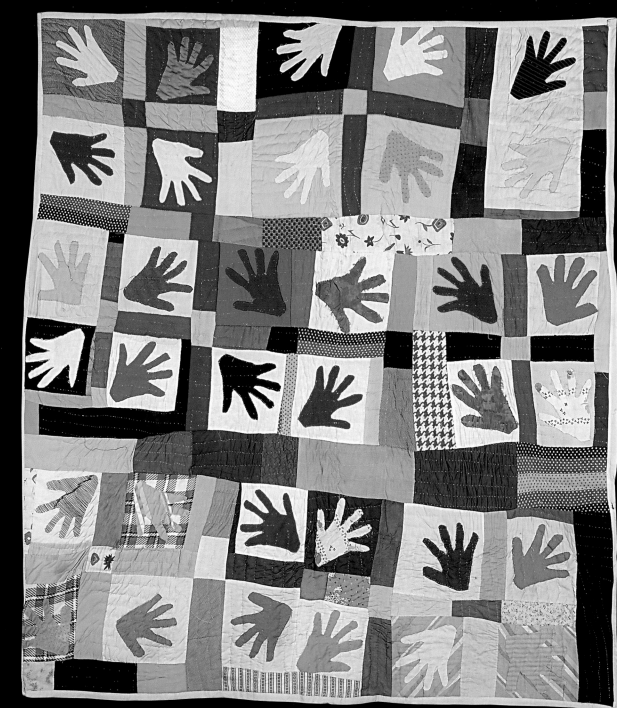

R

is for

reading

A girl is reading and the sunlight shines on her book.
Where else does the light shine?

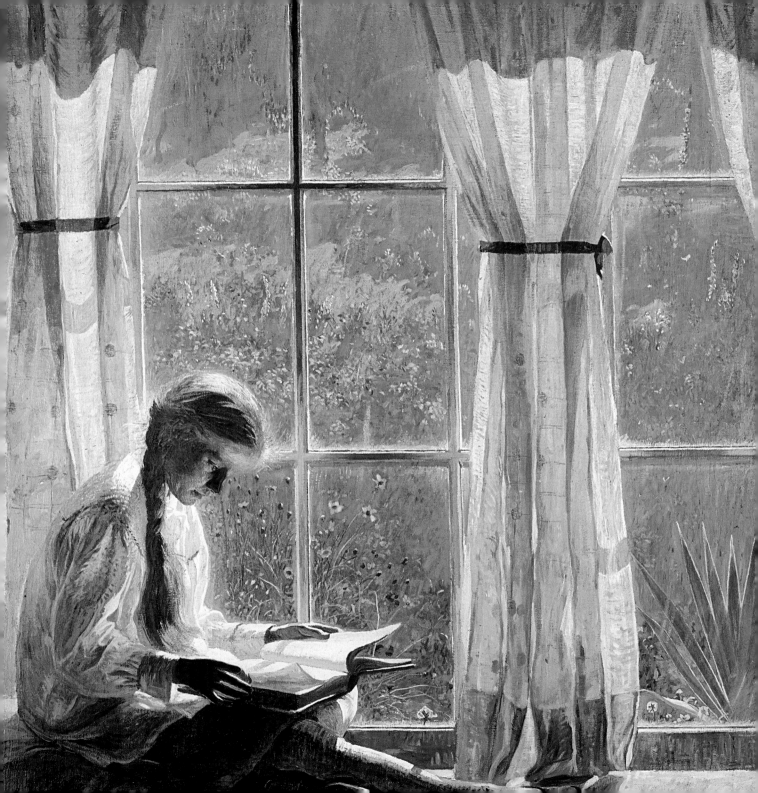

S

is for

sunflowers

Vincent van Gogh loved to paint sunflowers.
Can you see where he signed his name?

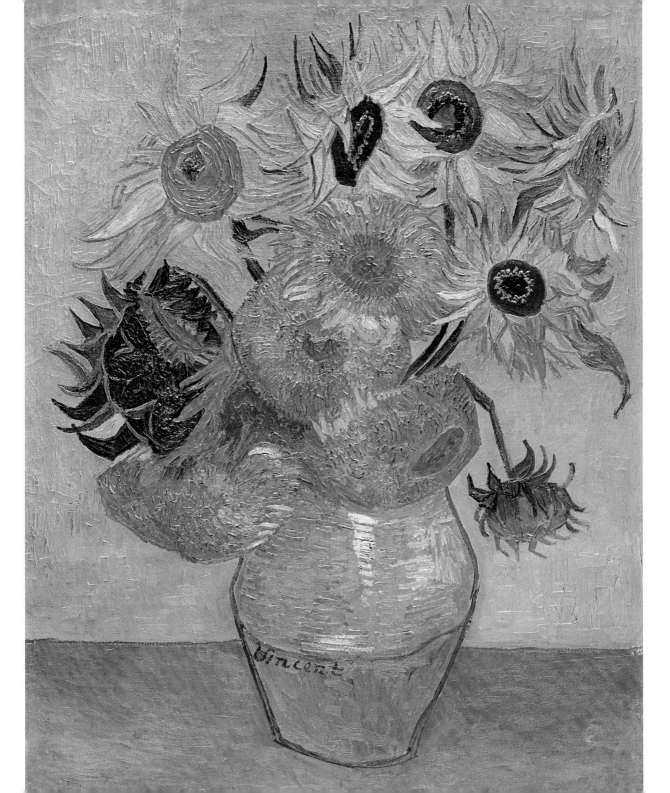

T

is for

teahouse

This Japanese house was built for drinking tea.
Can you find the windows, roofs, and fences?

Designed by Ogi Rodo (Japanese, 1863–1941), *Ceremonial Teahouse: Sunkaraku*, c. 1917

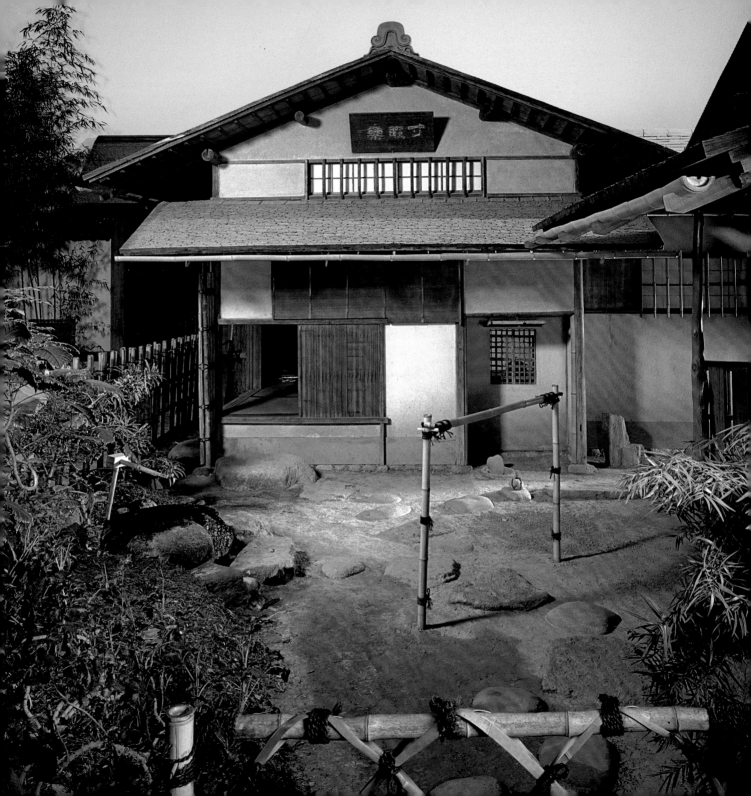

U

is for

umbrella

Two women stand under an umbrella.
Is it snowing? Raining? How can you tell?

Utagawa Toyokuni, called Toyokuni I (Japanese, 1769–1825), *Two Women under Umbrella in Snow*, 1807

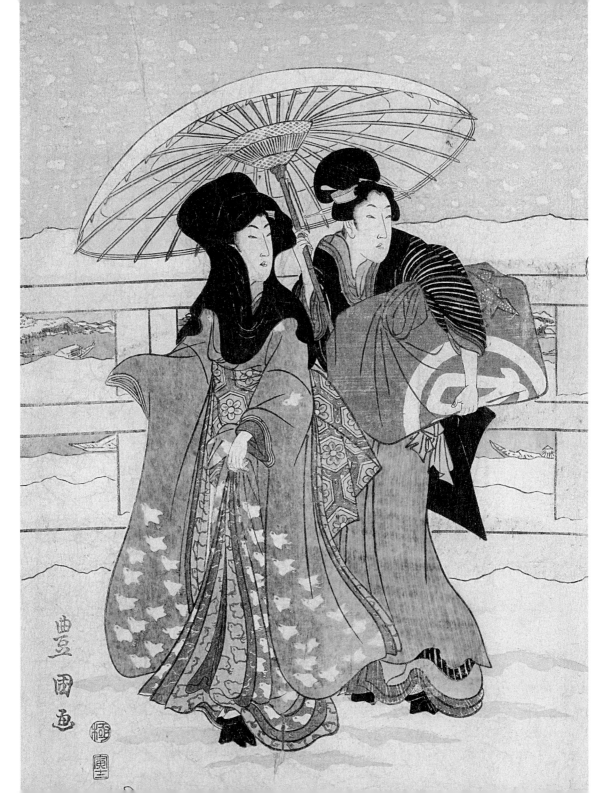

is for

vest

This vest has a whole kitchen on it!
What parts can you name?

Joan Steiner (American), *Kitchen Vest*, 1977

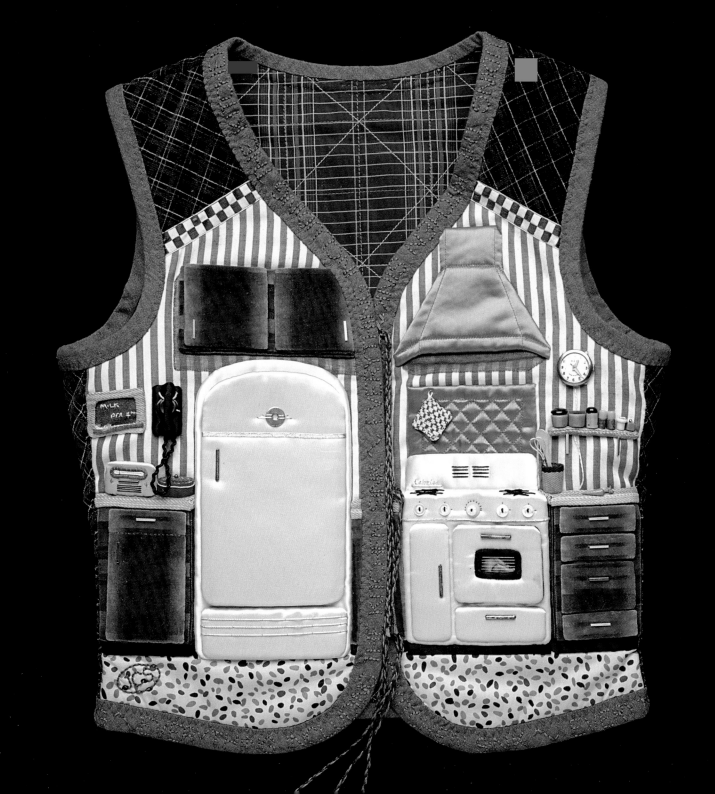

W

is for

woman

This woman balances a bowl on her head.
What do you think she carries in it?

Tina Modotti (Italian, 1896–1942), *Woman of Tehuantepec*, c. 1929

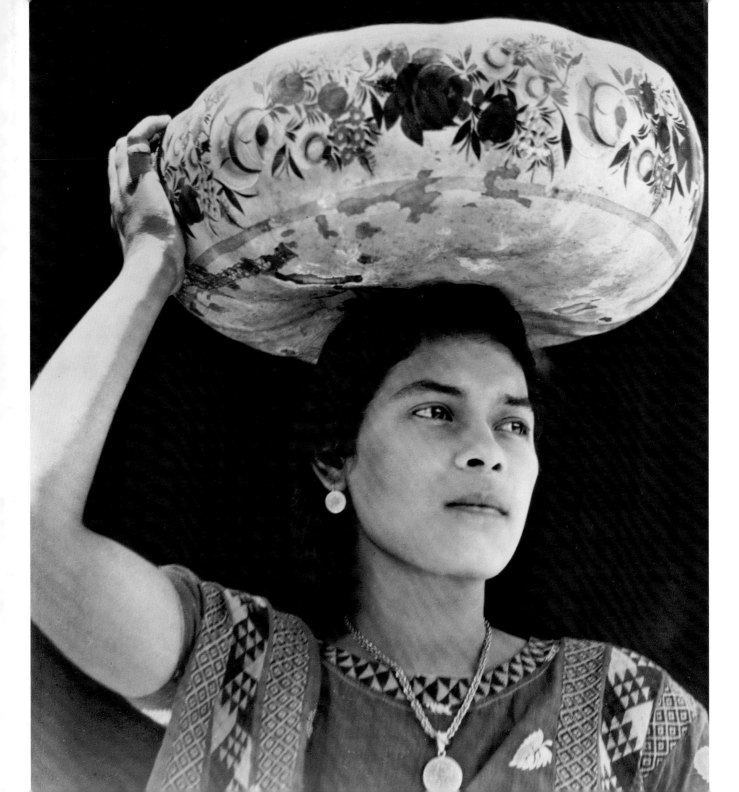

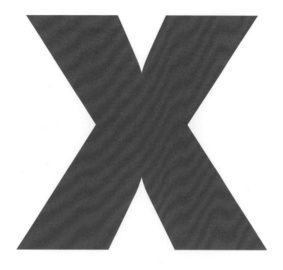

is for

X marks the spot! How many other shapes
can you find on the blue ceiling?

Sol LeWitt (American, 1928–2007), *On a Blue Ceiling, Eight Geometric Figures: Circle, Trapezoid,
Parallelogram, Rectangle, Square, Triangle, Right Triangle, X (Wall Drawing No. 351)*, 1981

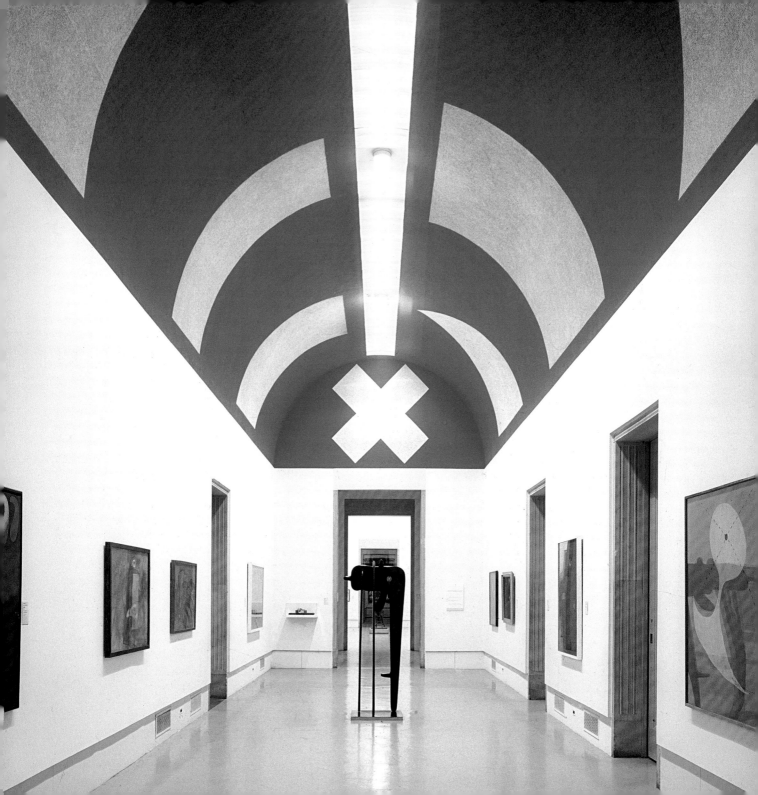

Y

is for

yellow

This lively creature is made up of lots of circles.
How many can you find?

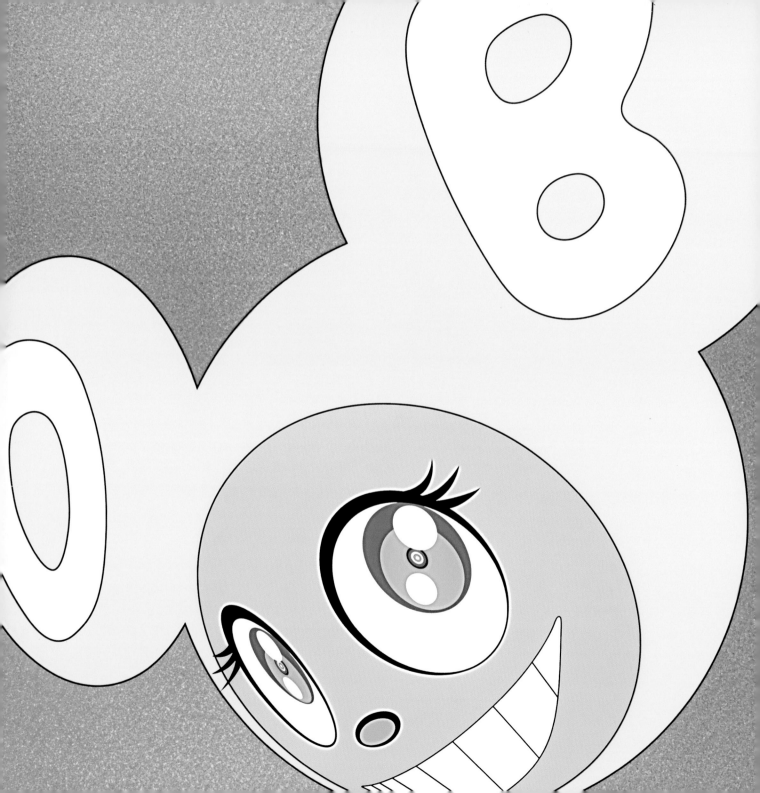

Z

is for

zebra

The animals walk to the ark two by two.
Can you find the zebras?
What other animals do you see?

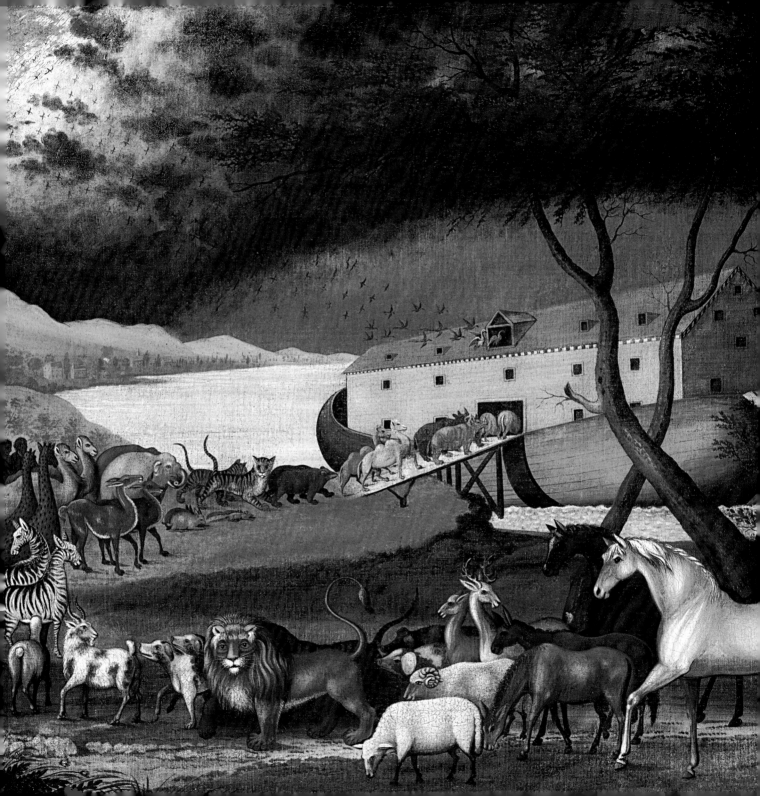

A Note to Grown-Ups

An art museum can be an exciting starting point for family discussions, playful games, and creative ideas. In this book, we have only begun to hint at the wonderful conversations you and your child can have while looking at works of art. Here are some other ideas for sparking your child's imagination:

Take turns playing the "I spy" game. What hidden things can you discover?

Compare two pictures. How are the images alike and how are they different?

Flip through this book and look for a specific color or shape. How many times can you find the color red? How many places can you find a triangle?

Guess what a person or animal in a picture likes to do or eat. If they could speak to you, what would they say?

Imagine what it would feel like to be inside of a picture. Would the weather be warm? Would the animals be friendly? Would the flowers smell sweet?

Take out your drawing materials and pick your favorite work of art in the book. Can you draw a picture using the same colors or the same kinds of lines?

Finally, if you are in Philadelphia, come visit the Philadelphia Museum of Art to see some of these magnificent works in person. Take your child on a treasure hunt through our galleries and see how many of the objects in the book you can find. (The Museum is constantly changing, so they might not all be on view at the same time.) Have fun exploring and we hope to see you soon!

Illustrations

East Entrance of the Philadelphia Museum of Art
Photograph by Graydon Wood

The Japanese Footbridge and the Water Lily Pool, Giverny
Claude Monet (French, 1840–1926)
1899
Oil on canvas
35 1/8 x 36 3/4 inches (89.2 x 93.3 cm)
The Mr. and Mrs. Carroll S. Tyson, Jr., Collection, 1963-116-11
Photograph by Eric Mitchell

Dog Cage (Goulong)
Artist/maker unknown
Chinese, Qing Dynasty (1644–1911), Qianlong Period, c. 1736–95
Brass with cloisonné enamel and gilt decoration; jade rings
45 1/2 x 32 x 24 3/4 inches (115.6 x 81.3 x 62.9 cm)
Gift of the Friends of the Philadelphia Museum of Art, 1964-205-1
Photograph by Graydon Wood

Little Dancer, Aged Fourteen
Hilaire-Germain-Edgar Degas (French, 1834–1917)
Bronze cast by Adrien Hébrard, Paris
Executed in wax 1878–81; cast in bronze after 1922
Bronze, tulle, and silk
Height: 39 inches (99.1 cm)
The Henry P. McIlhenny Collection in memory of Frances P. McIlhenny, 1986-26-11
Photograph by Graydon Wood

Eye Miniatures
Artist/maker unknown
English, c. 1780–1800
Watercolor on ivory
Gift of Joseph Carson, Hope Carson Randolph, John B. Carson, and Anna Hampton Carson in memory of their mother, Mrs. Hampton L. Carson, 1935-17-1–23
Photographs by Lynn Rosenthal

Fish Magic
Paul Klee (Swiss, 1879–1940)
1925
Oil and watercolor on canvas on panel
30 3/8 x 38 3/4 inches (77.1 x 98.4 cm)
The Louise and Walter Arensberg Collection, 1950-134-112
Photograph by Graydon Wood

Fragment of a Tapestry Showing a Courtly Couple
Artist/maker unknown
Flemish, c. 1500–1530
Wool
8 feet 2 1/4 inches x 5 feet 2 13/16 inches (249.6 x 159.5 cm)
Purchased with Museum and subscription funds, 1926-73-1
Photograph by Graydon Wood

Burgonet
Made by Anton Peffenhauser (German, active Augsburg; 1525–1603)
1586–91
Blackened, etched, and partially gilded steel; gilded brass; silk; modern leather
12 5/8 x 8 11/16 x 13 3/8 inches (32 x 22 x 34 cm)
Bequest of Carl Otto Kretzschmar von Kienbusch, 1977-167-129
Photograph by Graydon Wood

Chilly Observation
Charles Sidney Raleigh (American, born England; 1830–1925)
1889
Oil on canvas
29 13/16 x 43 7/8 inches (75.7 x 111.4 cm)
The Collection of Edgar William and Bernice Chrysler Garbisch, 1965-209-6
Photograph by Joe Mikuliak

South Philly (Mattress Flip Front)
Zoe Strauss (American, born 1970)
2001 (negative); 2003 (print)
Chromogenic print
Image: 6 7/8 x 10 1/8 inches (17.5 x 25.7 cm)
Sheet: 8 x 10 3/8 inches (20.3 x 26.4 cm)
Purchased with funds contributed by Theodore T. Newbold and Helen Cunningham, 2003-104-8
Photograph by Andrea Nuñez

The Kiss
Constantin Brancusi (French, born Romania; 1876–1957)
1916
Limestone
23 x 13 1/4 x 10 inches (58.4 x 33.7 x 25.4 cm)
The Louise and Walter Arensberg Collection, 1950-134-4
Photograph by Graydon Wood

The Libraries Are Appreciated
Jacob Lawrence (American, 1917–2000)
1943
From the Harlem series, No. 28
The Harlem Branch Library of the New York Public Library at 9 West 124th Street
Gouache over graphite on textured wove paper
Sheet: 14 3/4 x 21 5/8 inches (37.5 x 54.9 cm)
The Louis E. Stern Collection, 1963-181-40
Photograph by Eric Mitchell

Three Musicians
Pablo Ruiz y Picasso (Spanish, 1881–1973)
1921
Oil on canvas
80 1/2 x 74 1/8 inches (204.5 x 188.3 cm)
A. E. Gallatin Collection, 1952-61-96
Photograph by Graydon Wood

Portrait of a Polish Woman
Amedeo Modigliani (Italian, 1884–1920)
1919
Oil on canvas
39 1/2 x 25 1/2 inches (100.3 x 64.8 cm)
The Louis E. Stern Collection, 1963-181-48
Photograph by Graydon Wood

Ostrich Carousel Figure
Made by the Dentzel Carousel Company (Philadelphia, 1867–1928)
c. 1903–9
Painted basswood
75 1/2 x 45 x 23 1/2 inches (191.8 x 114.3 x 59.7 cm)
Gift of the Friends of the Philadelphia Museum of Art, 1976-158-1
Photograph by Eric Mitchell

P

*The Lover Rides His Horse Far into the Pond
to Let Him Drink*
Artist/maker unknown
India, Madhya Pradesh, Bundelkhand, c. 1800–1825
Opaque watercolor on paper
13 1/8 x 17 3/4 inches (33.3 x 45.1 cm)
Alvin O. Bellak Collection, 2004-43-2
Photograph by Lynn Rosenthal

Q

Piecework and Appliqué Quilt: "Hands"
Sarah Mary Taylor (American, 1916–2006)
1970–80
Pieced and appliquéd cotton and synthetic solid
and printed plain weave, twill, flannel, knit,
dotted swiss, and damask
83 1/4 x 78 inches (211.5 x 198.1 cm)
The Ella King Torrey Collection of African American
Quilts, 2006-163-11
Photograph by Graydon Wood

R

The Orchard Window
Daniel Garber (American, 1880–1958)
1918
Oil on canvas
56 7/16 x 52 1/4 inches (143.3 x 132.7 cm)
Centennial gift of the family of Daniel Garber, 1976-216-1
Photograph by Eric Mitchell

S

Sunflowers
Vincent Willem van Gogh (Dutch, 1853–1890)
1888 or 1889
Oil on canvas
36 3/8 x 28 inches (92.4 x 71.1 cm)
The Mr. and Mrs. Carroll S. Tyson, Jr., Collection,
1963-116-19
Photograph by Graydon Wood

T

Ceremonial Teahouse: Sunkaraku
Designed by Ōgi Rodō (Japanese, 1863–1941)
c. 1917
Purchased with Museum funds, 1928-114-1
Photograph by Graydon Wood

U

Two Women under Umbrella in Snow
Utagawa Toyokuni, called Toyokuni I
(Japanese, 1769–1825)
Edo Period (1615–1868), 1807
Color woodcut
Ōban tate-e: 14 3/4 x 9 7/8 inches (37.5 x 25.1 cm)
Gift of Mrs. Anne Archbold, 1946-66-113
Photograph by Will Brown

V

Kitchen Vest
Joan Steiner (American)
1977
Quilted printed plain weave cotton with appliquéd
synthetic satin and cotton velveteen, various trims,
embroidery, and found objects
Approximate length: 18 inches (45.7 cm)
Gift of Mrs. Robert L. McNeil, Jr., 1994-92-5
Photograph by Graydon Wood

W

Woman of Tehuantepec
Tina Modotti (Italian, 1896–1942)
c. 1929
Gelatin silver print
Image and sheet: 8 3/8 x 7 3/8 inches (21.3 x 18.7 cm)
Gift of Mr. and Mrs. Carl Zigrosser, 1968-162-40
Photograph by Andrea Nuñez

X

*On a Blue Ceiling, Eight Geometric Figures: Circle,
Trapezoid, Parallelogram, Rectangle, Square, Triangle,
Right Triangle, X (Wall Drawing No. 351)*
Sol LeWitt (American, 1928–2007)
1981
Wall drawing (chalk and latex paint on plaster)
15 feet 6 inches x 54 feet 7 inches (472.4 x 1663.7 cm)
Purchased with a grant from the National Endowment for
the Arts and with funds contributed by Mrs. H. Gates
Lloyd, Mr. and Mrs. N. Richard Miller, Mrs. Donald A.
Petrie, Eileen and Peter Rosenau, Mrs. Adolf Schaap,
Frances and Bayard Storey, Marion Boulton Stroud, and
two anonymous donors (by exchange), with additional
funds from Dr. and Mrs. William Wolgin, the
Daniel W. Dietrich Foundation, and the Friends of the
Philadelphia Museum of Art, 1982-121-1
Photograph by Graydon Wood

Y

*And then and then and then and then and then
(Yellow)*
Takashi Murakami (Japanese, born 1962)
1999
Printed by Hiropon Factory, Saitama, Japan
Color screenprint
Image: 15 3/4 x 15 3/4 inches (40.0 x 40.0 cm)
Sheet: 20 7/16 x 20 7/16 inches (51.9 x 51.9 cm)
Purchased with the Hunt Corporation (formerly Hunt
Manufacturing Co.) Arts Collection Program, 2001-180-2
Photograph by Andrea Nuñez

Z

Noah's Ark (detail)
Edward Hicks (American, 1780–1849)
1846
Oil on canvas
26 5/16 x 30 3/8 inches (66.8 x 77.1 cm)
Bequest of Lisa Norris Elkins, 1950-92-7
Photograph by Eric Mitchell

Acknowledgments

The authors wish to thank the following people for their invaluable assistance in making this book a reality: Sherry Babbitt; Barbara Bassett; Richard Bonk; Megan Cohen; Liza Dolmetsch; Sonal, Yuva, and Jasmine Gambhir; Andrea Hemmann; Amanda Jaffe; Jason Little; Andrea Nuñez; Jessica and Casey Sharpe; Mimi Stein; David Updike; Jennifer Vanim; and Graydon Wood. Finally, they thank Julien, Mary Beth, and Julia for their constant inspiration.

Published by the Philadelphia Museum of Art in association with Temple University Press

Temple University Press
1601 N. Broad Street
Philadelphia, PA 19122
www.temple.edu/tempress

Edited by David Updike
Production by Richard Bonk
Designed by Andrea Hemmann, GHI Design, Philadelphia
Printed and bound in Singapore by CS Graphics, PTE, Ltd.

Back cover: East Entrance of the Philadelphia Museum of Art. Photograph by Nick Kelsh.

Page 2: The Great Stair Hall in the Philadelphia Museum of Art. Photograph by Andrea Nuñez.

Page 4: Sonal, Yuva, and Jasmine Gambhir contemplate Pablo Picasso's *Three Musicians* during a visit to the Philadelphia Museum of Art. Photograph by Graydon Wood.

Text and compilation © 2008 Philadelphia Museum of Art

Work by Constantin Brancusi © 2008 Artists Rights Society (ARS), New York / ADAGP, Paris.

Work by Daniel Garber reproduced by permission of Dana (Garber) Applestein.

Work by Paul Klee © 2008 Artists Rights Society (ARS), New York / VG Bild-Kunst, Bonn.

Work by Jacob Lawrence © 2008 The Jacob and Gwendolyn Lawrence Foundation, Seattle / Artists Rights Society (ARS), New York.

Work by Sol LeWitt © 2008 The LeWitt Estate / Artists Rights Society (ARS), New York.

Work by Takashi Murakami © 1999 Takashi Murakami / Kaikai Kiki Co., Ltd. All Rights Reserved.

Work by Pablo Picasso © 2008 Estate of Pablo Picasso / Artists Rights Society (ARS), New York.

Work by Joan Steiner reproduced by permission of the artist.

Work by Zoe Strauss reproduced by permission of the artist.

Every effort has been made to contact the copyright holders for works reproduced herein. Any omissions are unintentional.

Library of Congress Cataloging-in-Publication Data

Friedland, Katy, 1978–
 A is for art museum / Katy Friedland, Marla K. Shoemaker.
 p. cm.
 ISBN 978-0-87633-203-0 (PMA hardcover) —
 ISBN 978-1-59213-963-7 (TUP hardcover)
 1. Art—Juvenile literature. I. Shoemaker, Marla K., 1951– II. Philadelphia Museum of Art. III. Title.
 N5308.F75 2008
 700—dc22
 2008018194

2 4 6 8 9 7 5 3 1

A B C D

E F G H

I J K L

M N O P